# NORTH CAROLINA
## *Wonder and Light*

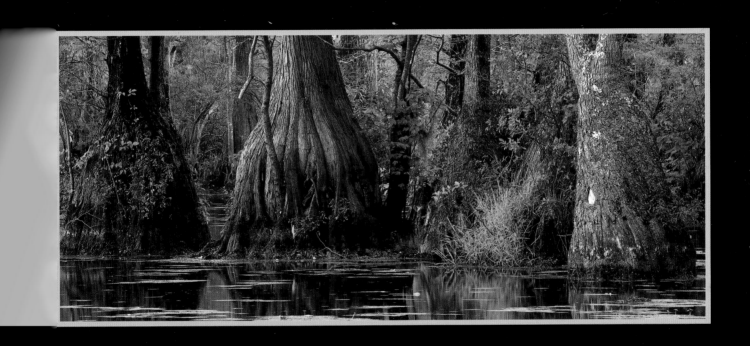

Photography by

# JERRY D. GREER

# NORTH CAROLINA
## *Wonder and Light*

Photography by Jerry D. Greer

# Mountain Trail
## Press

1818 Presswood Road   Johnson City , Tennessee 37604
www.mountaintrailpress.com

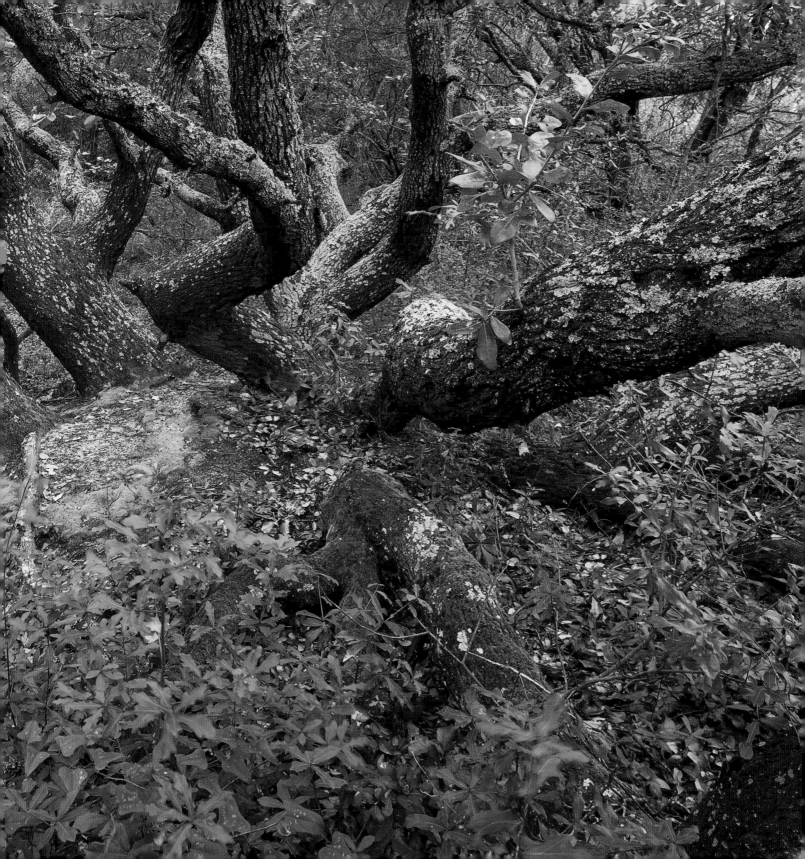

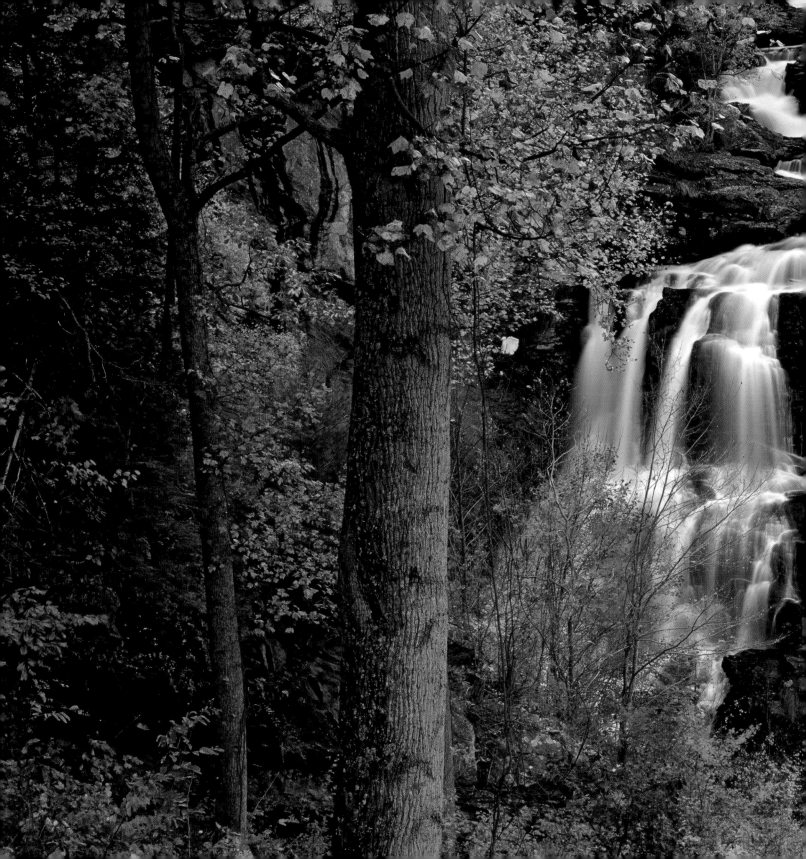

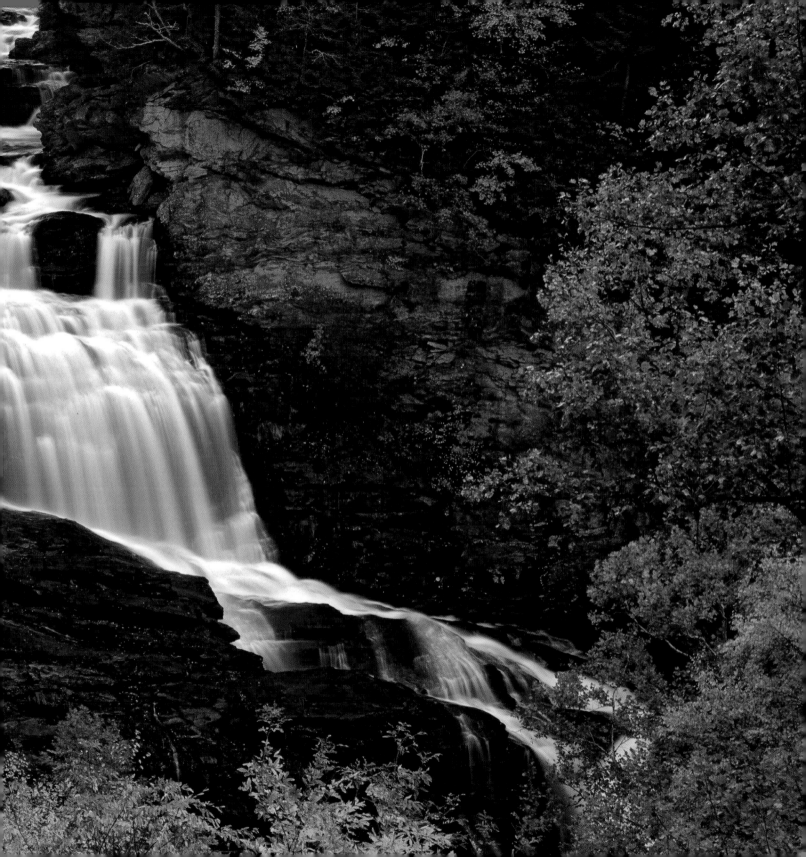

# NORTH CAROLINA
*Wonder and Light*

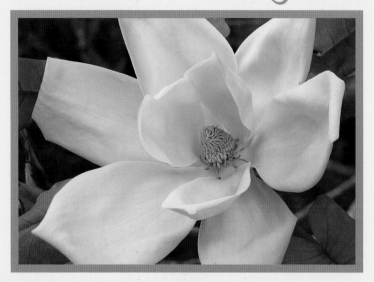

# Photography by Jerry D. Greer

Book design: Jerry D. Greer and Ian J. Plant
Editor: Todd Caudle and Ian J. Plant
Entire Contents Copyright © 2006 Mountain Trail Press LLC
Photographs © Copyright Jerry D. Greer 2006
All Rights Reserved
No part of this book may be reproduced in any form
without written permission from the publisher
Published by Mountain Trail Press LLC
1818 Presswood Road.
Johnson City, TN 37604
ISBN: 0-9770808-3-8
Printed in Korea
First Printing, Spring 2006

*Front cover:* Autumn color and fog accentuates Crabtree Falls, Blue Ridge Parkway
*First Frontispiece:* Cypress and tupelo reflections, Merchant Mill Pond State Park
*Second Frontispiece:* Maritime forest of live oaks, Jockey's Ridge State Park
*Third Frontispiece:* The Autumn season paints Cullasaja Falls in reds, yellows and greens,
Nantahala National Forest
*Above:* Fraser magnolia blossom, Pisgah National Forest
*Right:* Autumn reflection in Bass Lake, Moses H. Cone Memorial Park, Blue Ridge Parkway

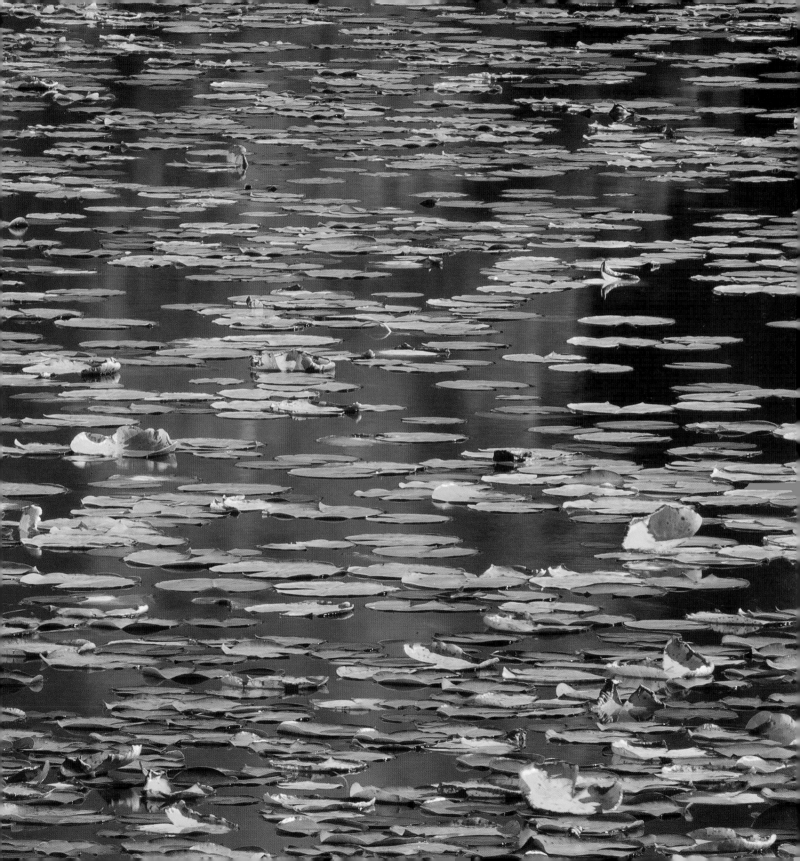

**Rain, rain, go away!**

While having dinner at Howard's Pub, a local landmark on Ocracoke Island, I could hear the wind, rain and distant thunder of an incoming weather front. I pondered the possibilities for the next morning's photo adventure to Cape Point. Would it be a failed attempt at a sunrise, or would the weather gods bestow their grace upon me and award my adventure the glorious light I dreamt about for the past month? Well, if the weather forecast was to be believed, it should be perfect! The prediction was for the storm to move offshore at daybreak—a photographers dream!

I arose at 4:00a.m. to a screeching alarm clock, a little earlier than normal to accommodate the 20-minute ferry ride from Ocracoke to Hatteras. Drawing on past experience, I decided to get everything ready the night before so all I needed to do was load the truck and be on my way to the dock, just a 15-minute drive from where I was staying. Once onboard, I settled in for a 20-minute catnap.

After making landfall, I had another 15-minute drive to Buxton before hooking up with the beach route, suitable for 4x4 vehicles only, at Ramp 44 to Cape Point. The map displays the point as a little hook-like spit of land that is the beginning of the infamous Diamond Shoals. This hook of land is a point of confluence for two opposing currents—the warm Gulf Stream moving north, and a cold Virginian current moving south. When onshore winds are stirred into the mix of the two divergent currents, big waves ensue. Such was the case on this particular morning. All I needed was for the sky to open to the east.

When I arrived at Cape Point, the sky was just starting to lighten. With remnants of the storm still hugging the horizon, I had a few extra minutes before the sun would breach the cloudbank. My biggest worry was the 30-knot sustained winds, but I was lucky that they originated from the northwest, allowing me to use my body as a wind block for the camera. To make sharp images, a steady

*Foreword*

by Jerry D. Greer

camera is a must! I had read in many books and articles that if there are high winds, there would be angry seas. What an understatement! As the sun started peeking through gaps in the clouds, I cast aside my uneasiness of being in the midst of such angry seas. Common sense be damned, and I moved out to the very tip of Cape Point. I was suddenly surrounded on three sides by water. It was wonderful! Crashing waves with windblown tips, and sea spray soaking me and my gear. But all I needed to make all this hardship worthwhile was for the sky to open. When it did, it was a moment instantly seared into my memory! I fired off shot after shot as the waves were crashing just offshore. All the while I was unaware that a succession of wind-driven waves was on its way toward me. I did notice, in the right side of my viewfinder, an anomaly in the wave structures coming into the scene. At that moment, even as I was firing the shutter, a wave blindsided me from behind. Startled by the frigid seawater, my first thoughts were of sheer terror! The waves were strong enough to knock me off balance. I went down on one knee for a split second before regaining my balance, grabbed my tripod with camera still mounted, and headed away from the point. All the while I was trying to regain my composure and grasp the spectacular sunrise before me. As I turned to the horizon, the tiny bit of beach I was standing on was glistening with the reflected glory of the beautiful sunrise. Instinctively, I fired off a few more images.

Cold, wet and still shaken from the experience, I felt like those incredible waves had christened me with their fury.

I now have a better understanding of why so many people love the Outer Banks, and why they desire to live near such a mysterious and beautiful place. For most of the last ten years I've almost exclusively roamed the mountains and valleys of North Carolina. I had seldom ventured into the Piedmont or coastal regions. With such grand scenes like Grandfather Mountain, the Blue Ridge Parkway, Mount Mitchell, Joyce Kilmer Memorial Forest, Cullasaja Gorge and

Great Smoky Mountains National Park, I had the mistaken impression that I didn't need to go anyplace else. I must now admit, I've been a little too narrowly focused.

Beginning in March of 2005, while working on this book, I discovered the other places that North Carolinians call home, from the lofty heights of the Blue Ridge Mountains to the foothills of the Piedmont and the pristine coastal regions. I must say, from the mountains to the sea, what a grand state! As a native Virginian and a transplanted Tennessean, I'm proud to call NC my home away from home!

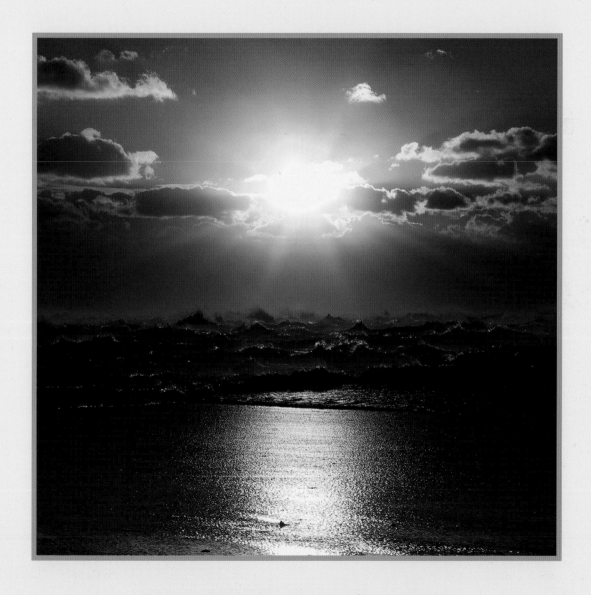

*Above:* Sunrise and angry seas, Cape Point, Cape Hatteras National Seashore
*Left:* Cape Hatteras Lighthouse, Cape Hatteras National Seashore
*Overleaf:* Oconaluftee River after a late spring rain, Great Smoky Mountains National Park

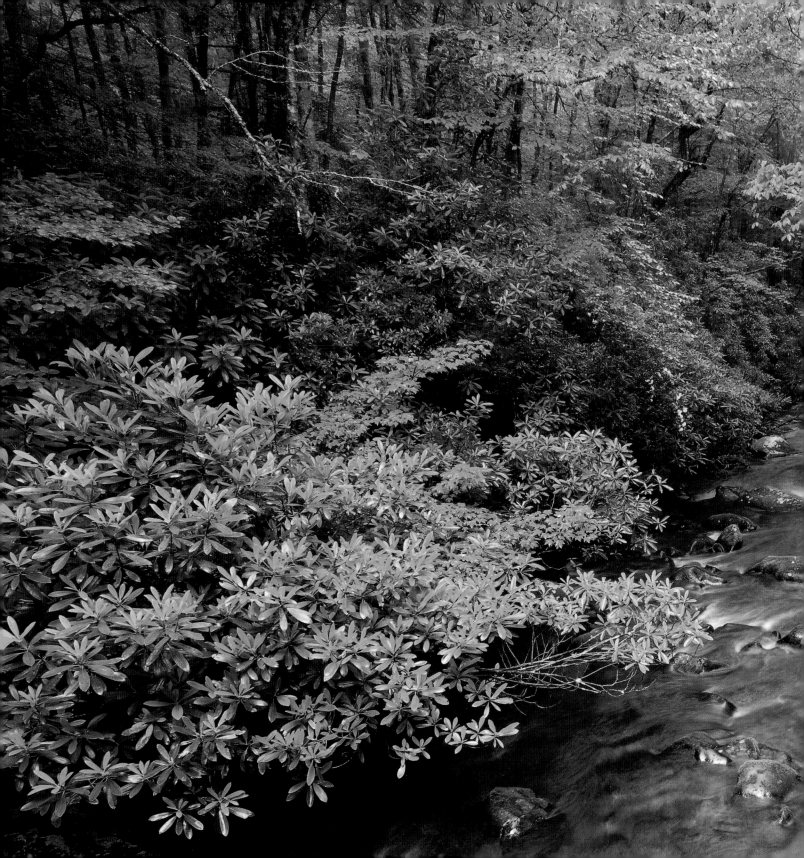

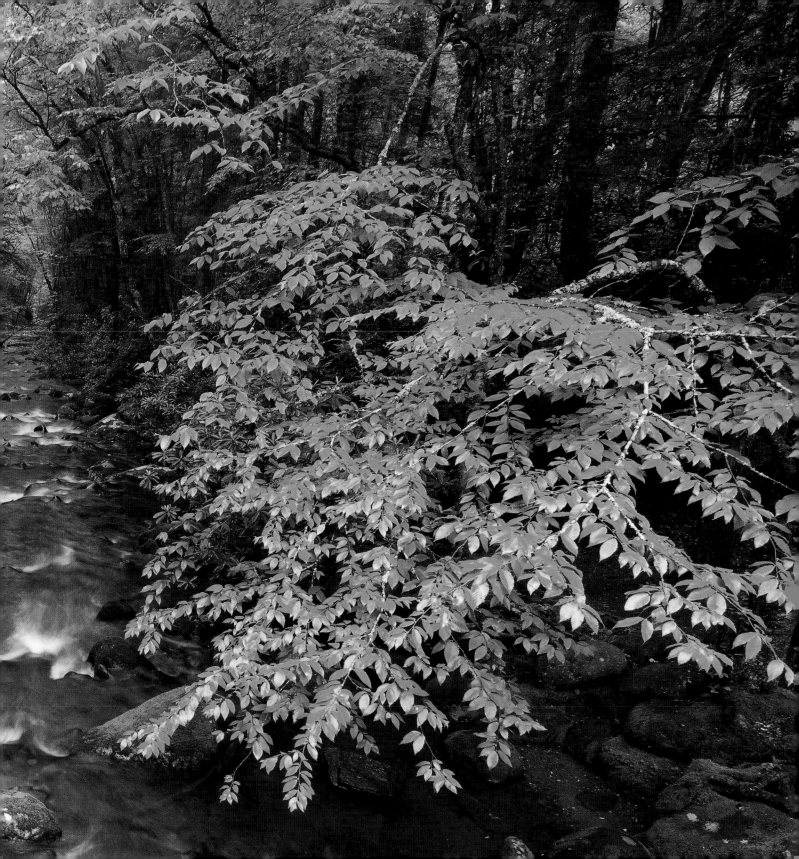

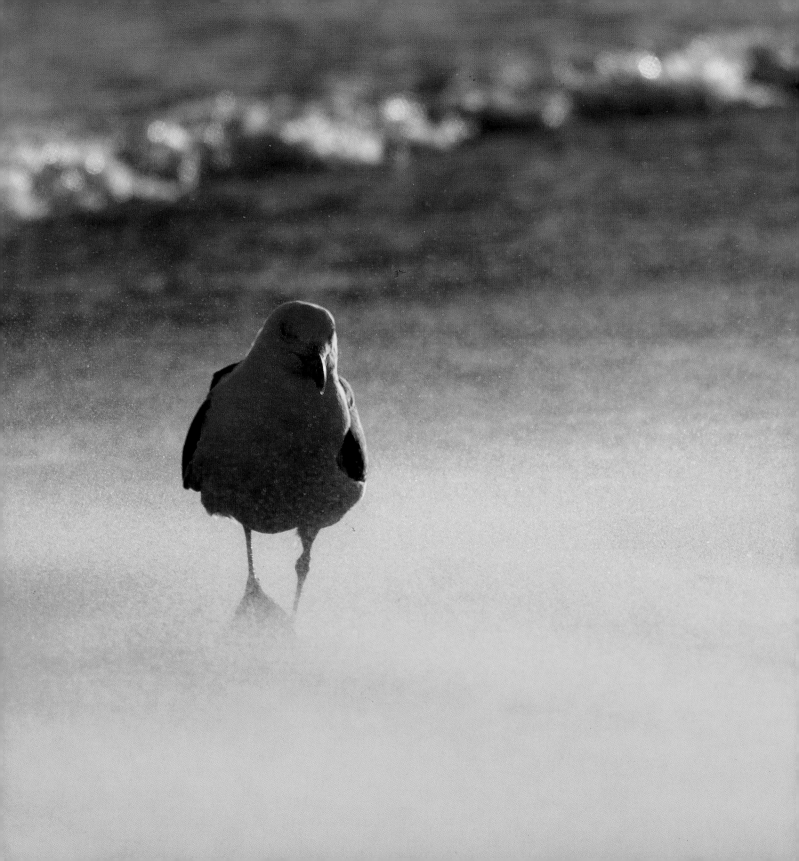

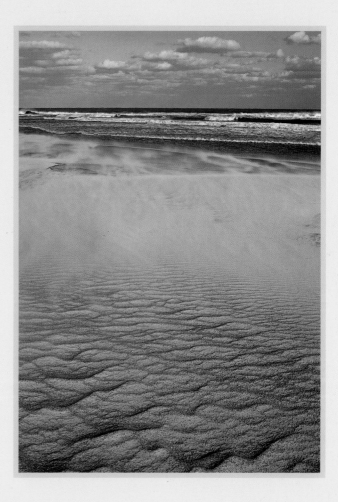

W INTER WINDS along the shores of the Outer Banks are a
normal occurrence. This mew gull will spend its day in a
coastal sandstorm.

*Above:* Wind-sculpted beach, Cape Hatteras National Seashore

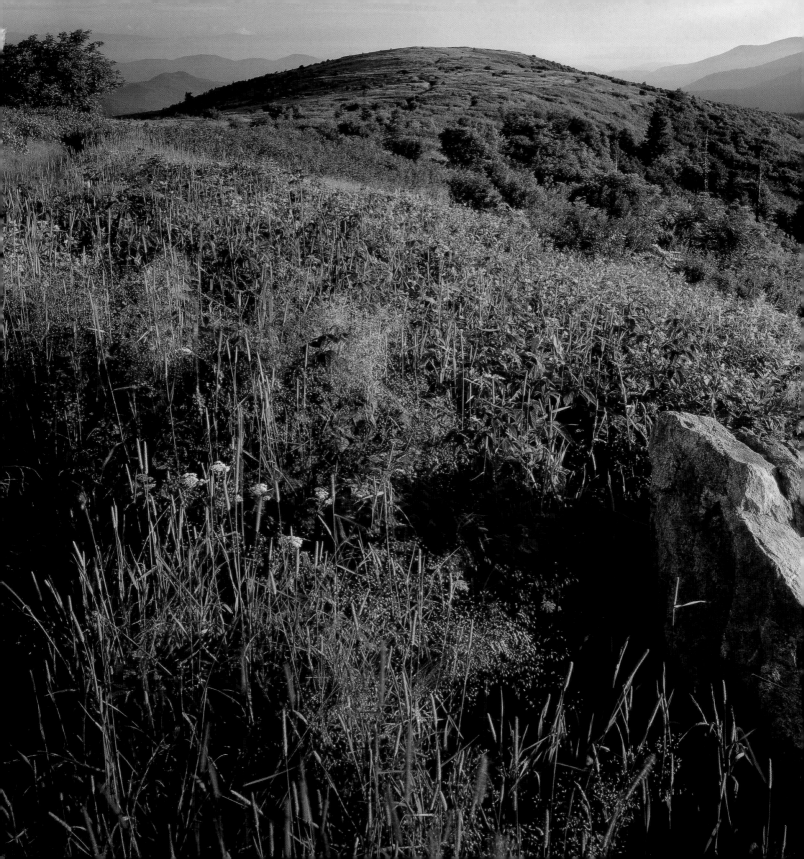

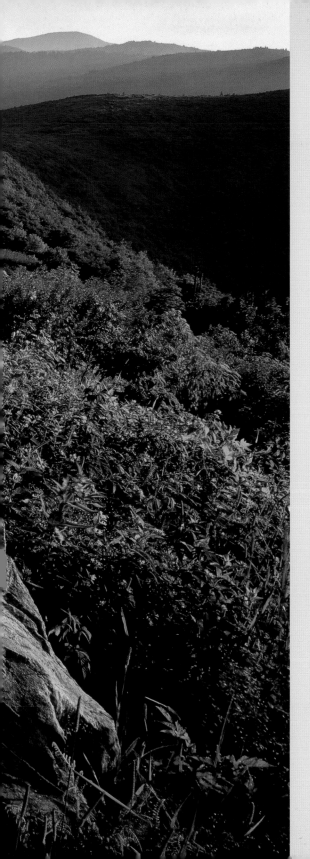

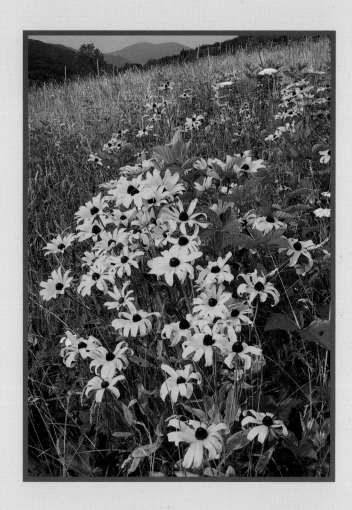

T HE ART LOEB TRAIL meanders its way along the high, treeless ridgetops of the Shining Rock Wilderness Area.

*Above:* Flower garden along the slopes of Max Patch Mountain

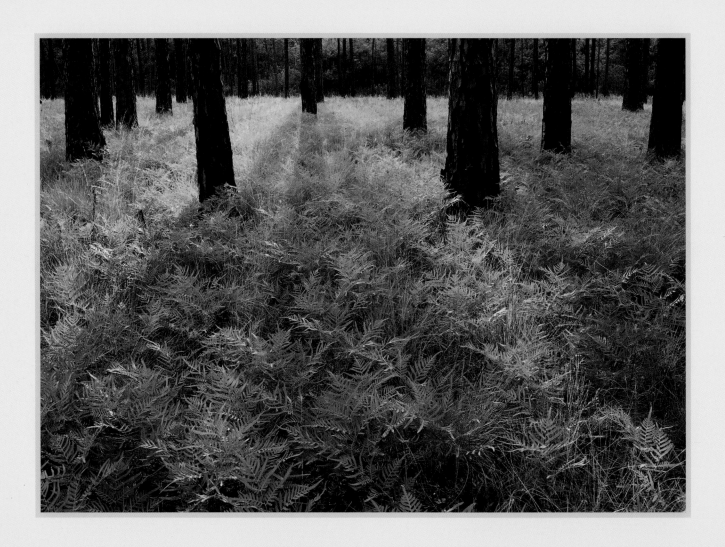

Sunset patterns, Green Swamp Preserve

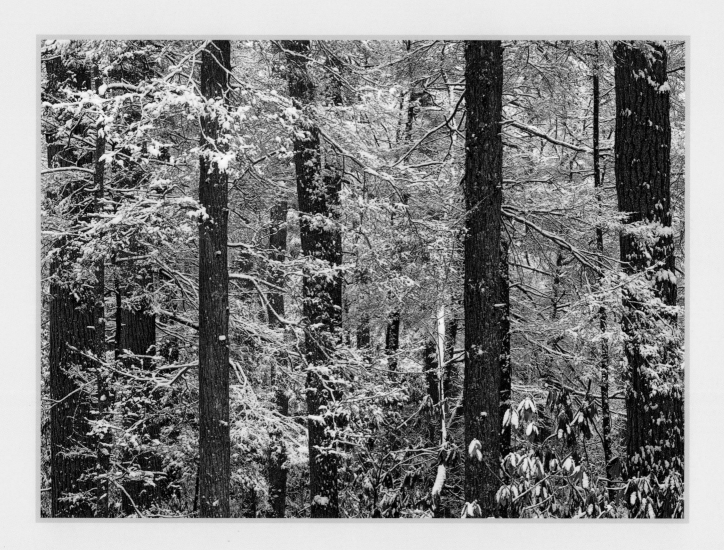

Snow-covered hemlock forest, Pisgah National Forest

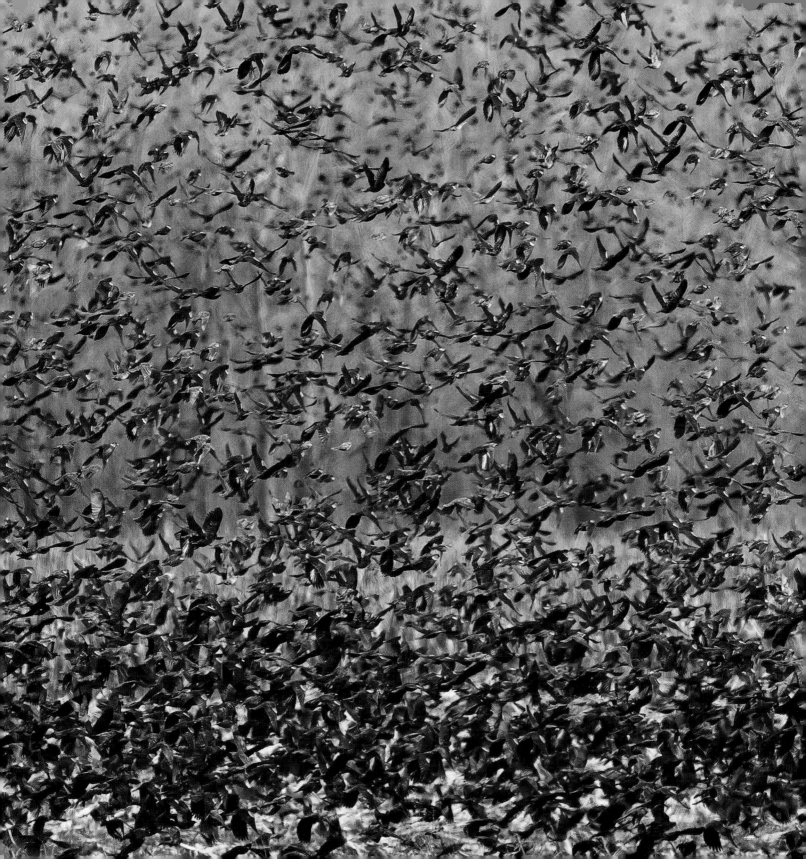

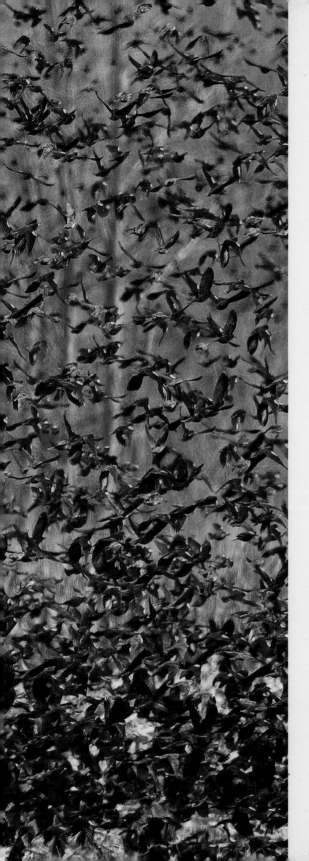

R ED-WINGED BLACKBIRDS taking flight, Pocosin Lakes National Wildlife Refuge.

*Above:* Winter cattails, Pocosin Lakes National Wildlife Refuge

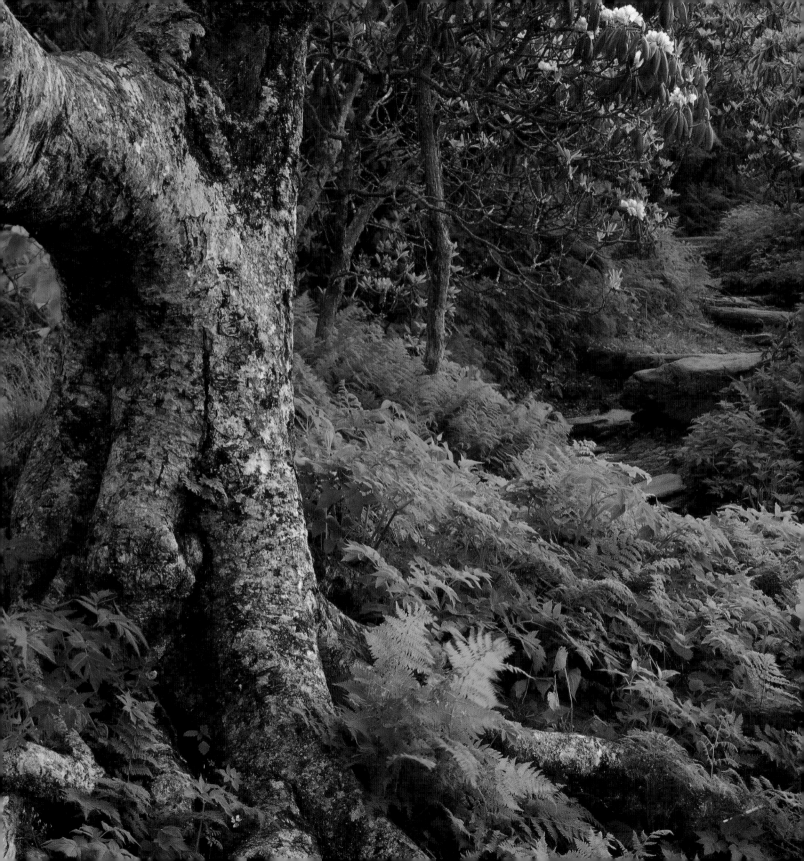

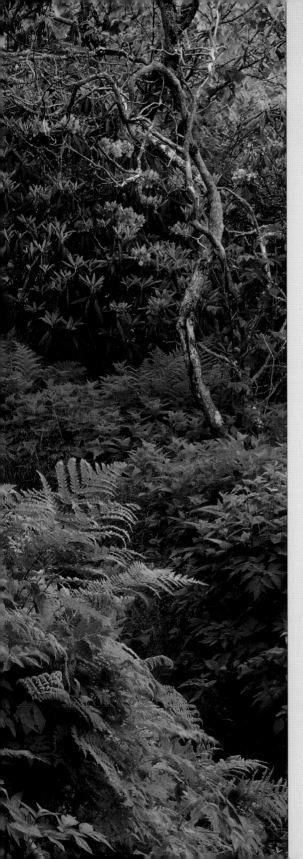

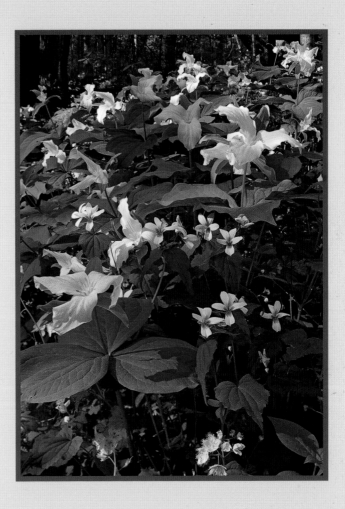

CRAGGY GARDENS is home to one of the most spectacular floral displays of Catawba rhododendron along the 469-mile Blue Ridge Parkway corridor.

*Above:* White trillium flourishes in the moist woods and coves of the Great Smoky Mountains National Park

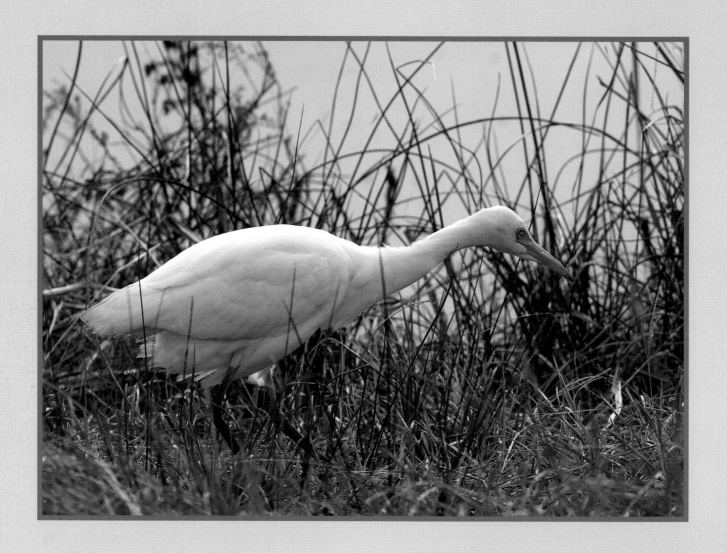

Great egret hunting for an evening meal, Mattamuskeet National Wildlife Refuge

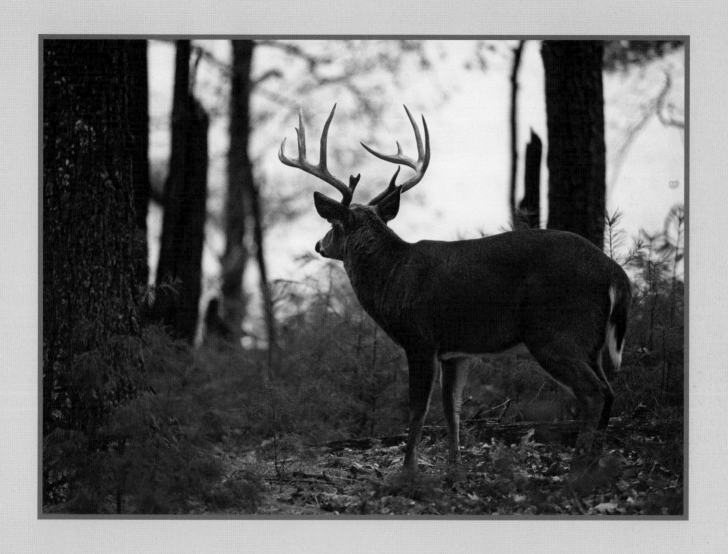

White-tailed deer, Cataloochee Valley, Great Smoky Mountains National Park

Overleaf: Spring maples provide color to the upland pine forests of the Pee Dee National Wildlife Refuge

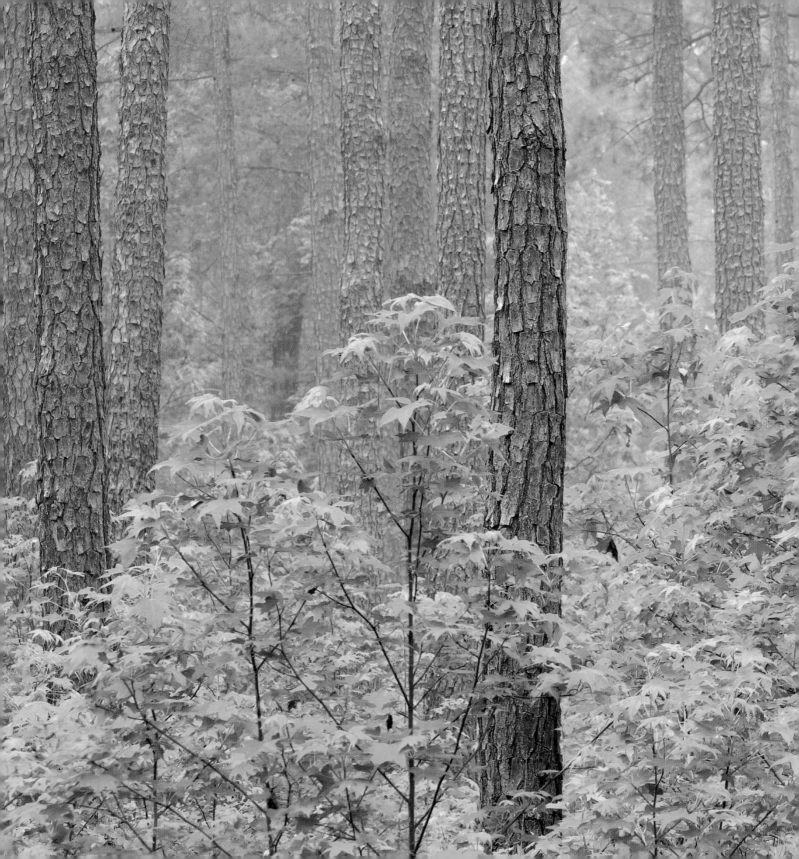

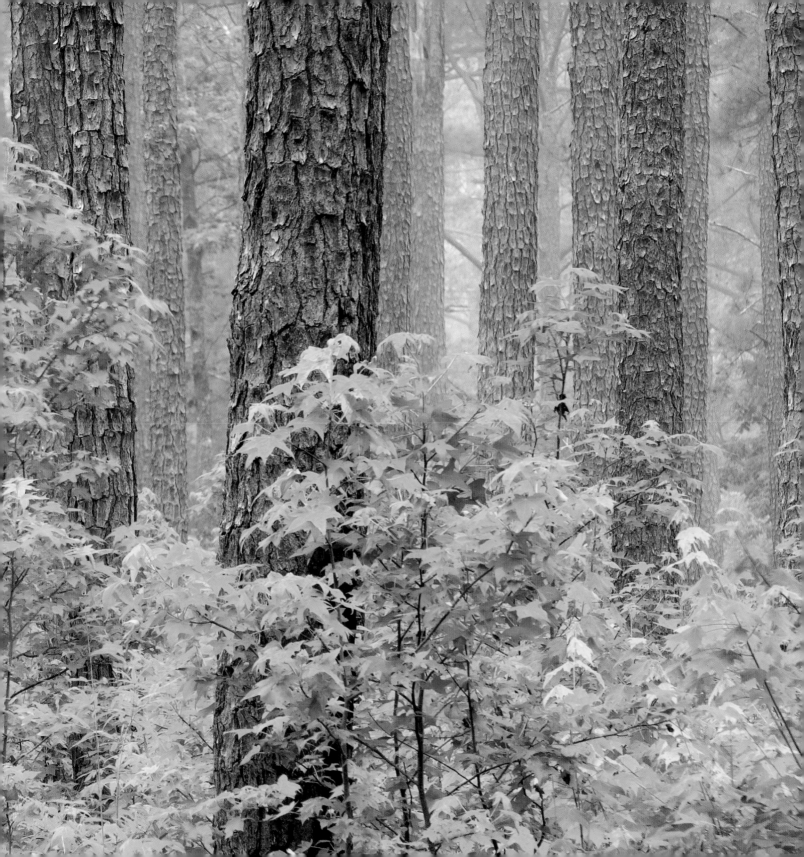

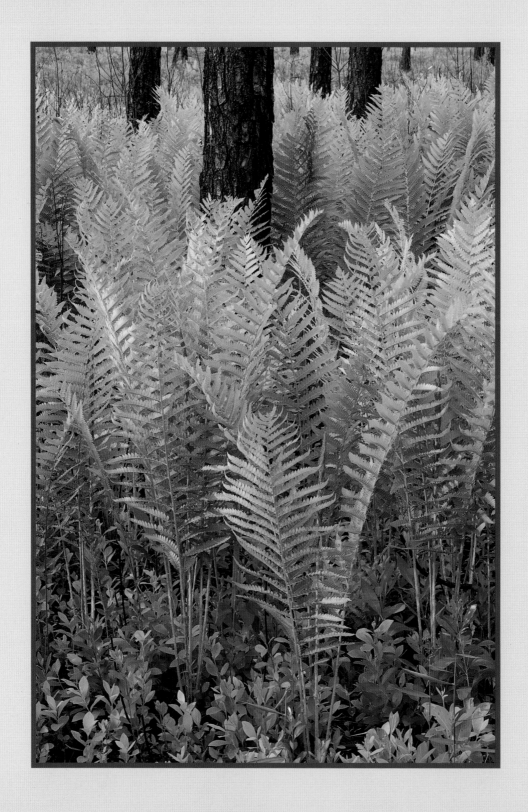

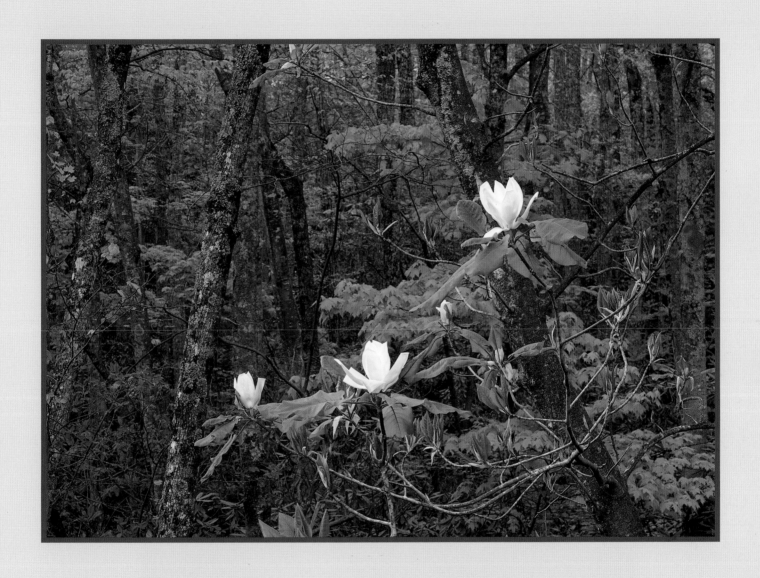

*Above:* Blooms of the beautiful Fraser magnolia decorate the forest of Stone Mountain State Park

*Left:* Cinnamon ferns thrive in the  prescribe burn  longleaf pine savannas of Green Swamp Preserve

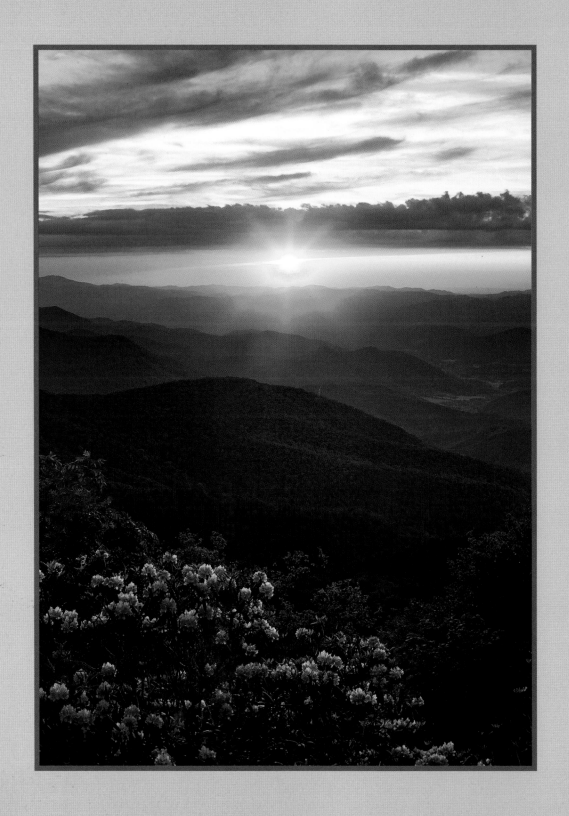

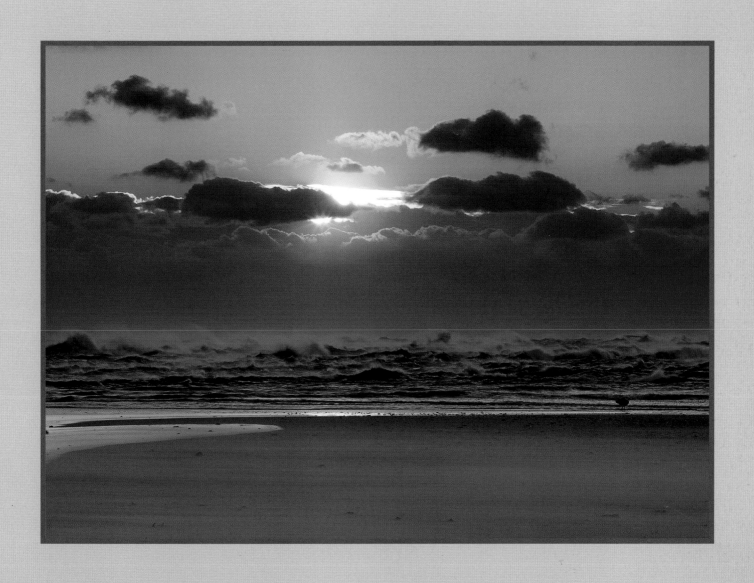

*Above:* Angry seas at Cape Point, Cape Hatteras National Seashore

*Left:* Sunset and blooming rhododendron, Craggy Gardens, Blue Ridge Parkway

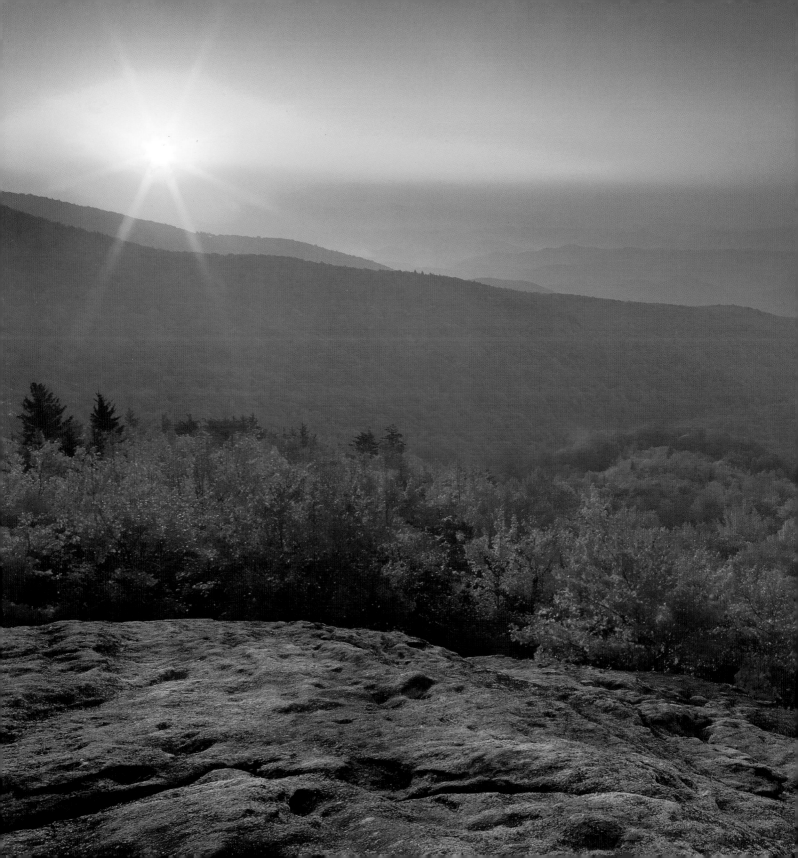

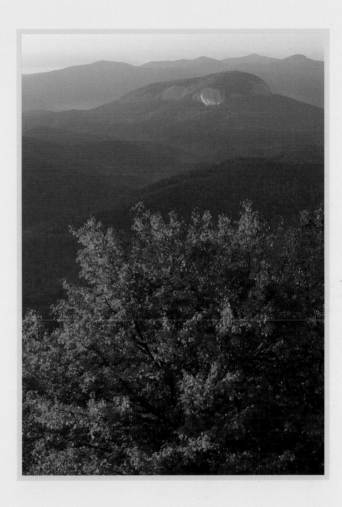

A UTUMN SUNRISE along the lower slopes of Grandfather Mountain, Blue Ridge Parkway.

*Above:* Autumn maple and Looking Glass Rock, Pisgah National Forest

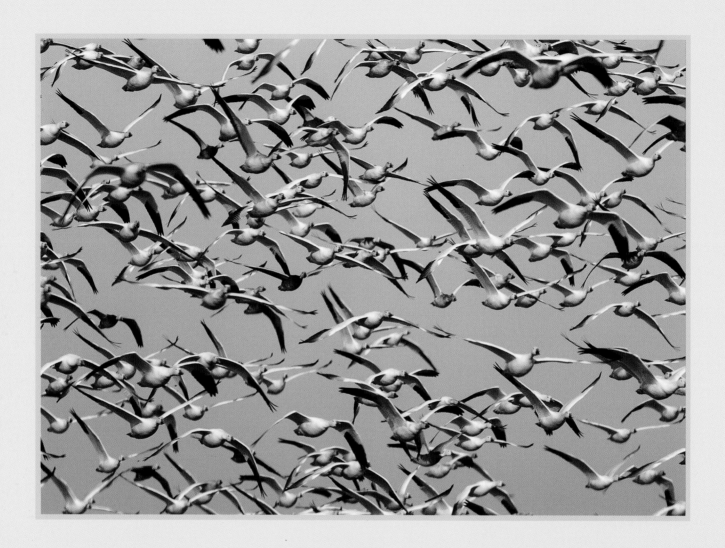

Snow geese in flight, Pocosin Lakes National Wildlife Refuge

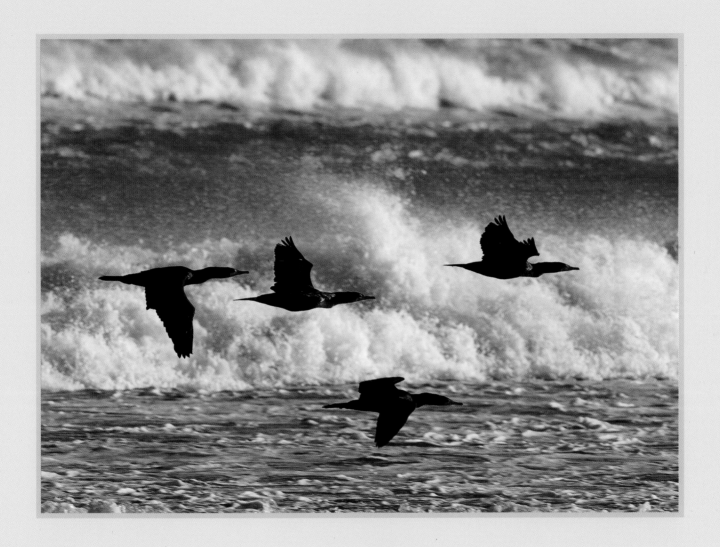

Double-crested cormorants over heavy surf, Southpoint, Ocracoke Island

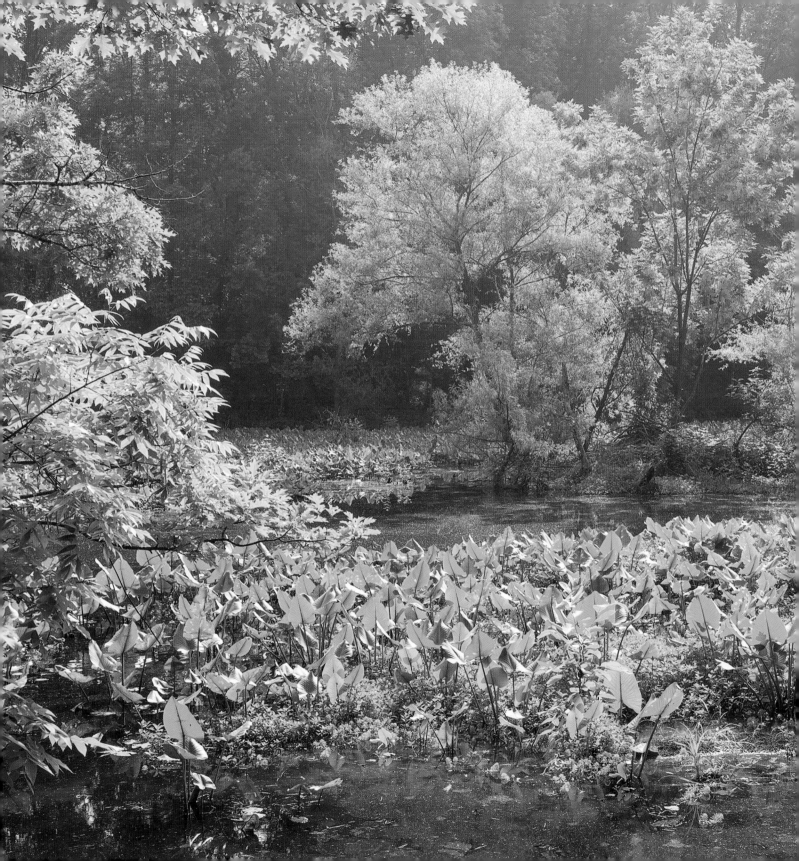

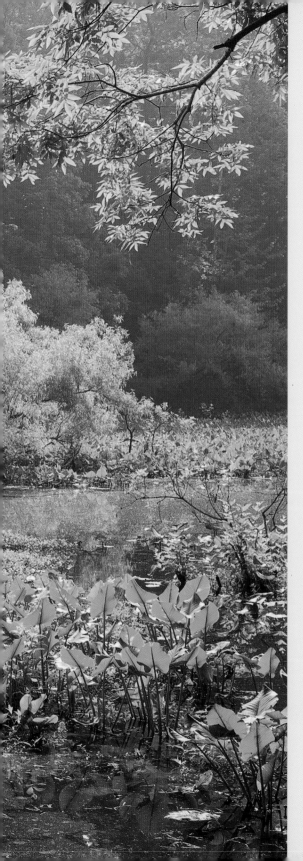

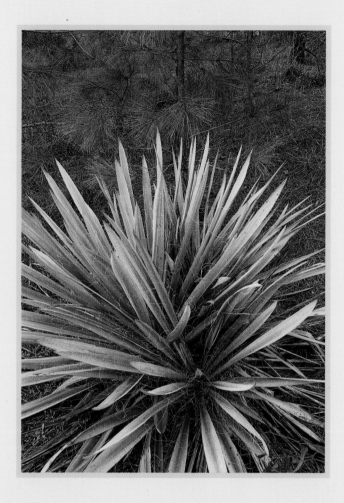

S PRINGTIME VISTA at the beaver ponds, Pee Dee National Wildlife Refuge.

*Above:* Coastal yucca and loblolly Pine, Nags Head Woods

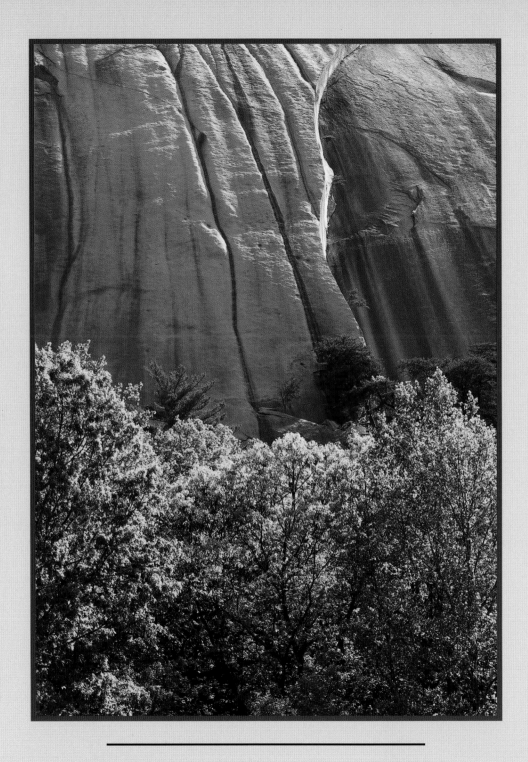

Spring forest and sunlit granite, Stone Mountain State Park

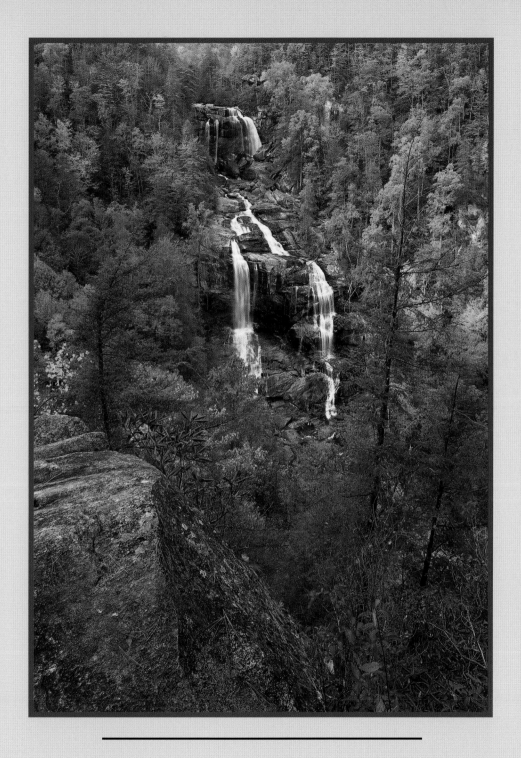

Autumn color decorates Whitewater Falls, Nantahala National Forest

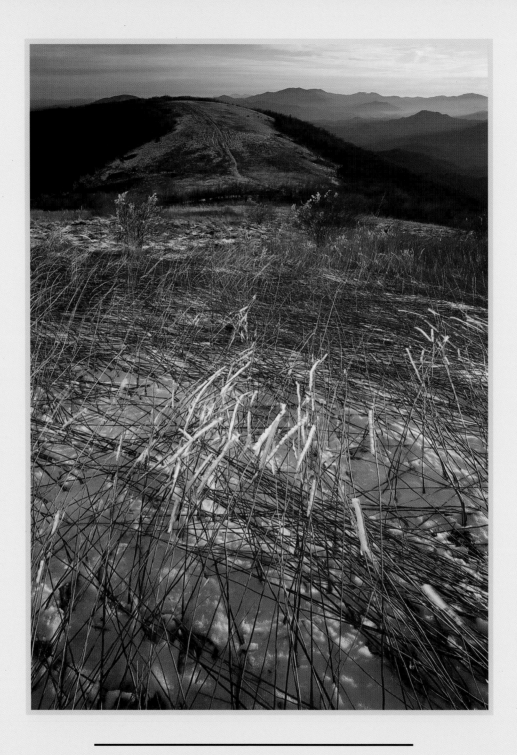

Early morning light paints the snowy landscape with warm hues, Big Stamp, Bald Mountains

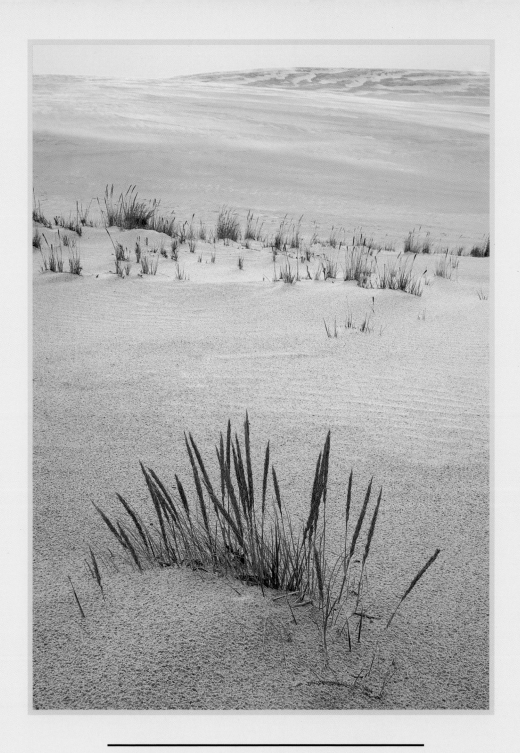

Windblown dunes, Jockey's Ridge State Park

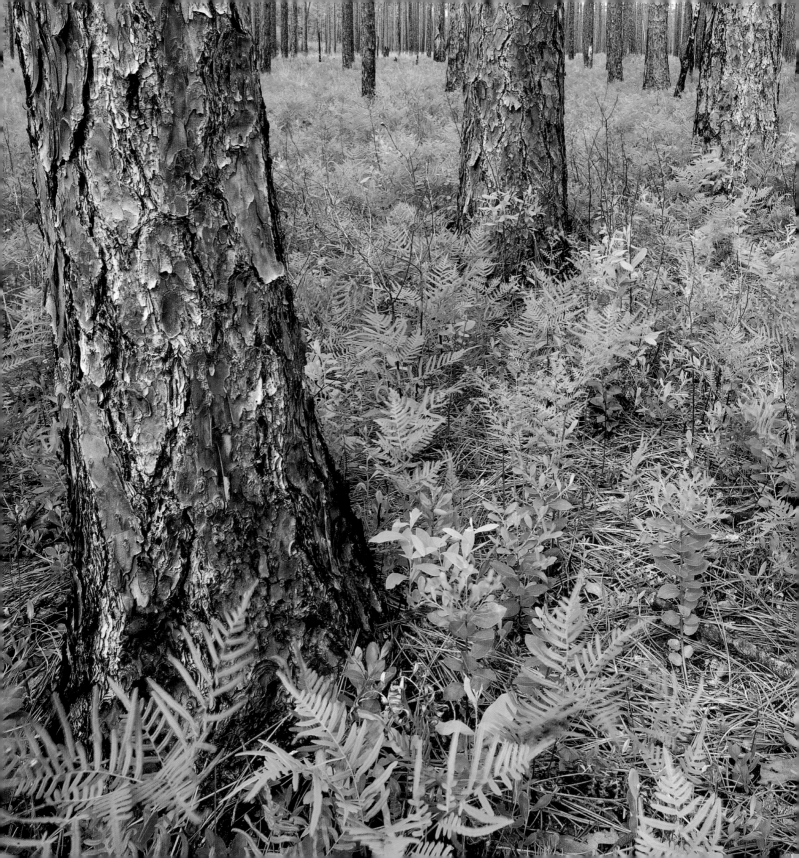

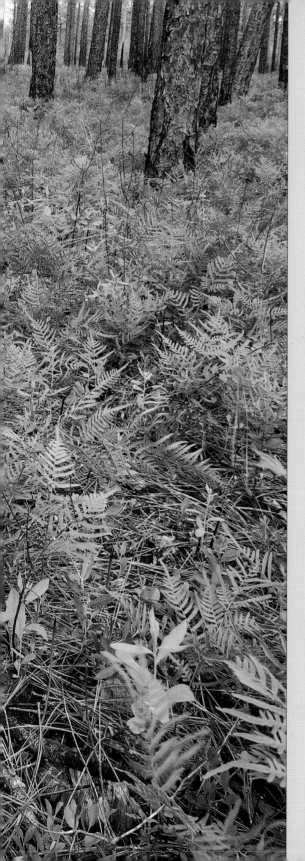

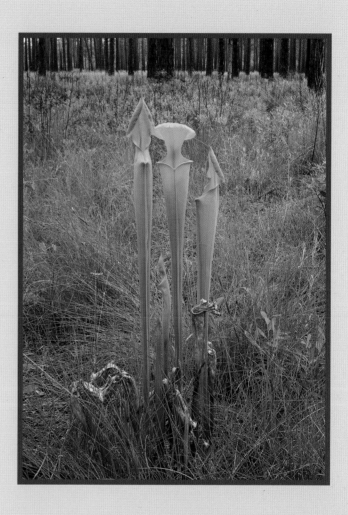

GREEN SWAMP PRESERVE contains some of America's finest examples of longleaf pine savannas. The open savannas have a diverse herb layer with many orchids and insectivorous plants.

*Above:* The showy pitcher plant grows in eastern wetlands and mountain bogs of North Carolina. The traps vary in length dependent of the species; those of the yellow pitcher plant can grow to 36 inches in height.

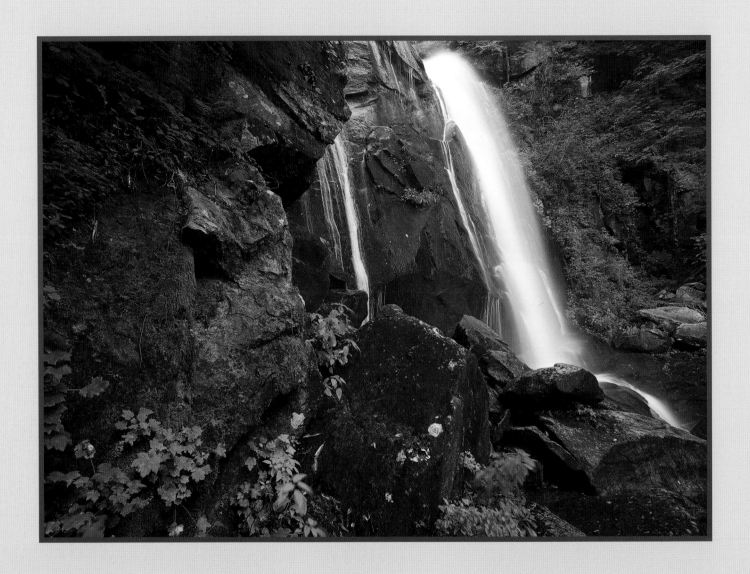

Jacobs Fork River plunges over High Shoals Falls, South Mountains State Park

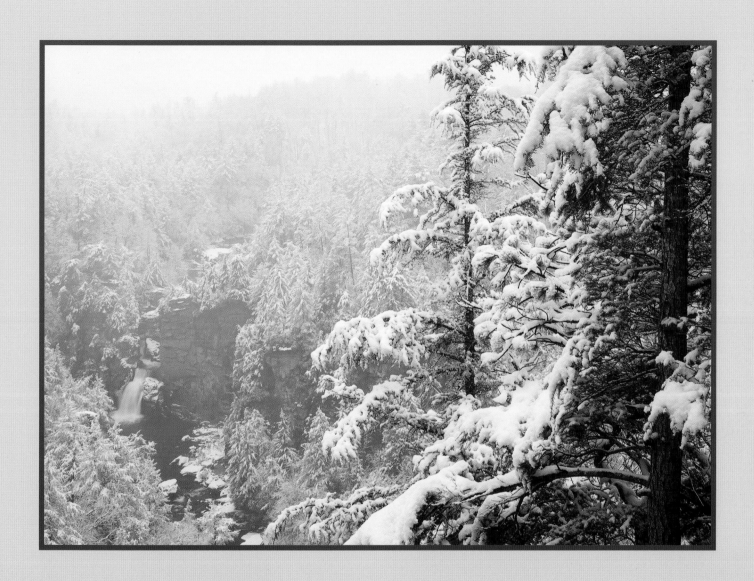

Winter storm, Linville Falls, Blue Ridge Parkway

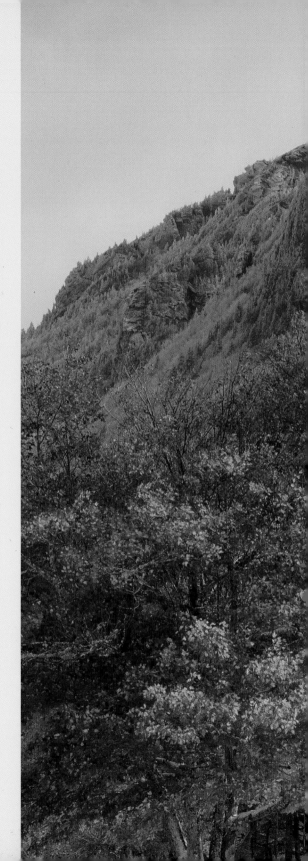

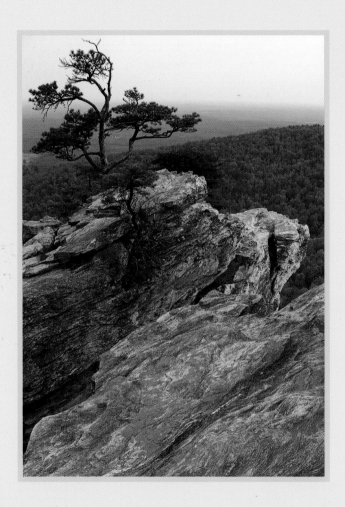

G RANDFATHER MOUNTAIN has been a wildlife sanctuary
and nature preserve for over 100 years. As one of the highest
peaks in the Blue Ridge Range it has been a destination for
naturalists for over 200 years. Naturalists Andre Michaux and John Muir
once visited here.

*Above:* Rocky crags at Hanging Rock, Hanging Rock State Park

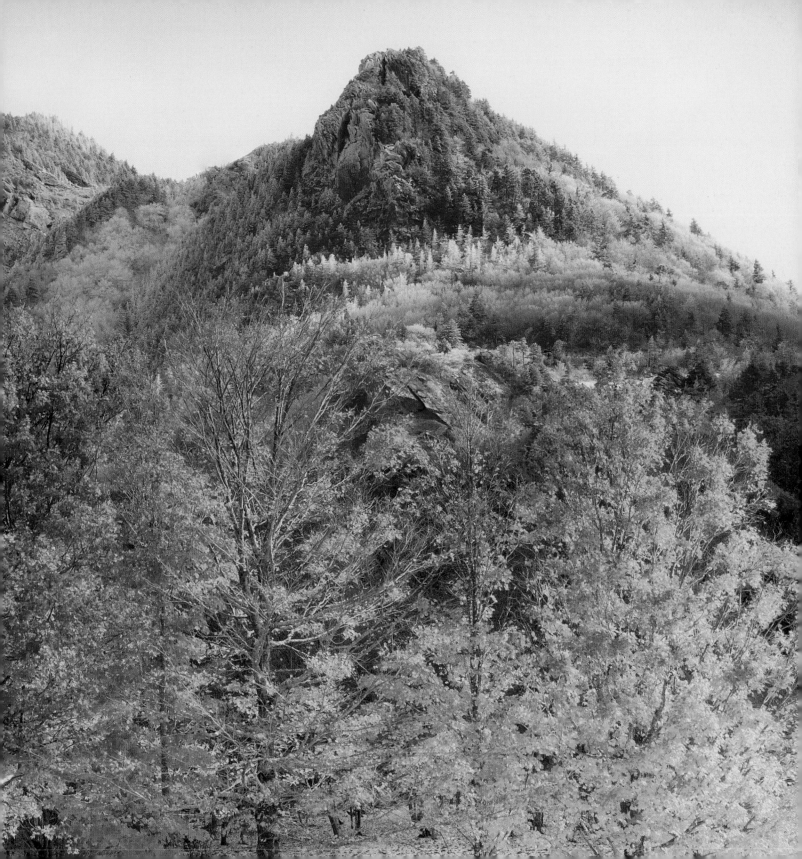

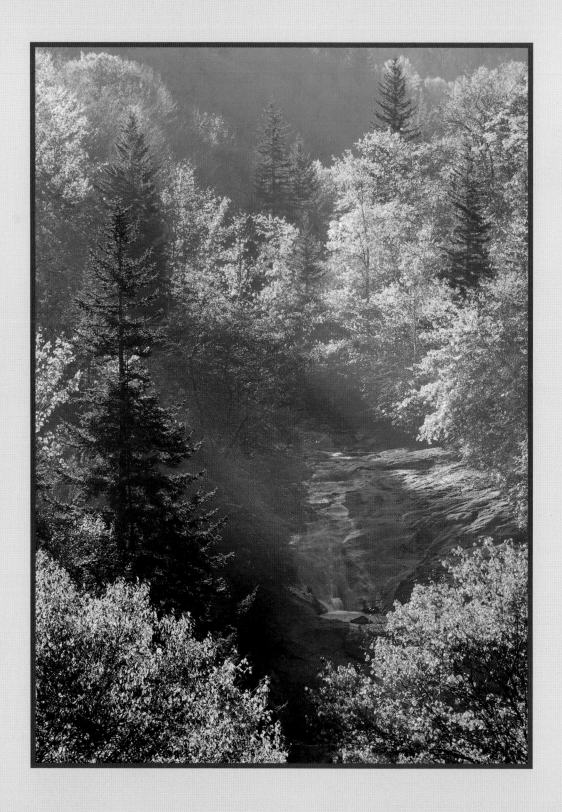

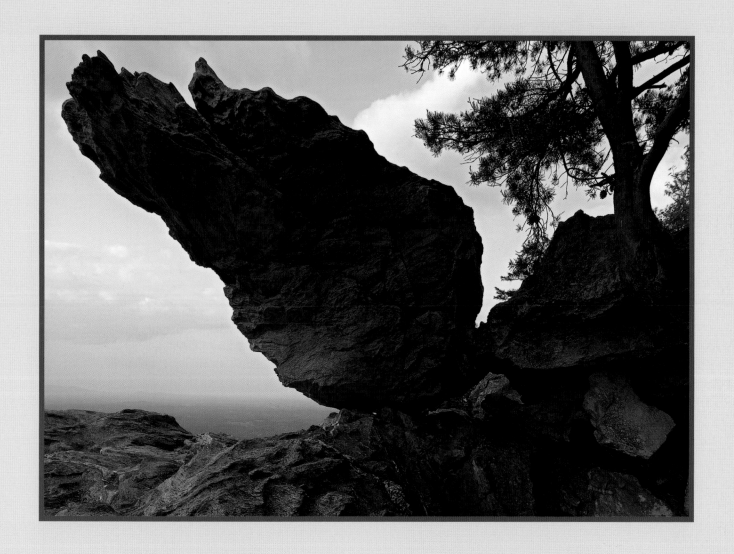

*Above:* Hanging Rock overlooks the Piedmont, Hanging Rock State Park

*Left:* Autumn color is accentuated by early morning fog and sunbeams, West Prong of the Pigeon River, Pisgah National Forest

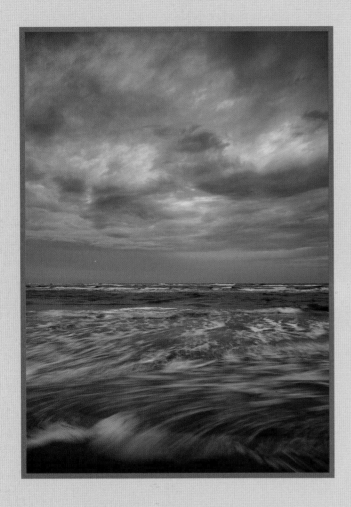

N ORTH CAROLINA'S 320-MILE-LONG COAST is a wintering haven for thousands of shorebirds. Shorebirds are a diverse group, comprised of curlews, godwits, dotterels and lapwings, plovers, avocets and stilts, oystercatchers, snipes and sandpipers. Some shorebirds migrate several hundred miles between breeding and wintering habitats.

*Above:* Winter morning along Ocracoke Beach, Cape Hatteras National Seashore

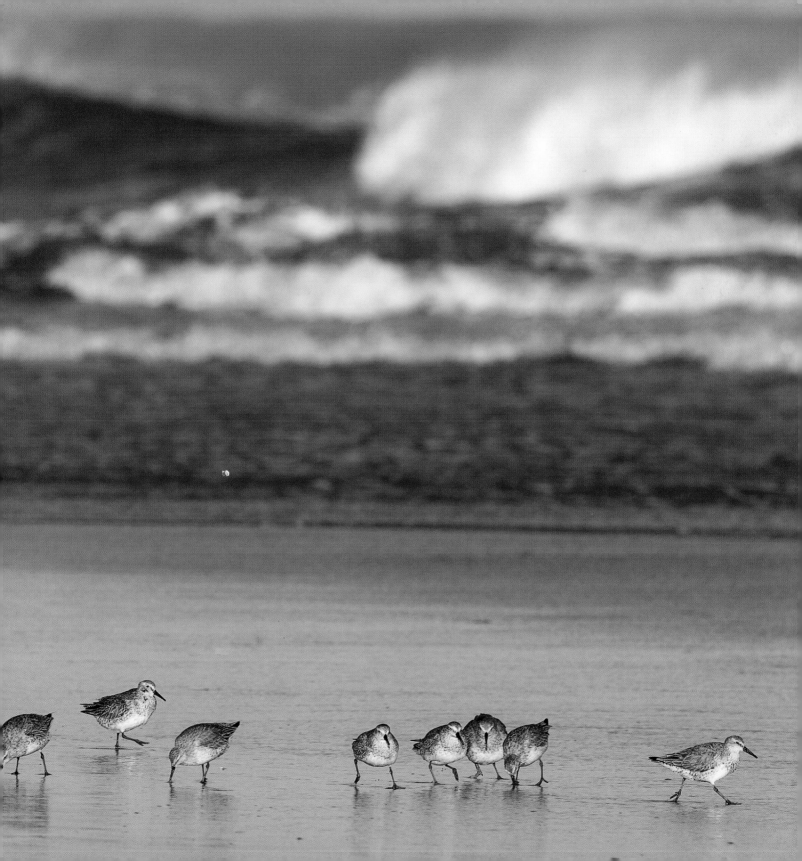

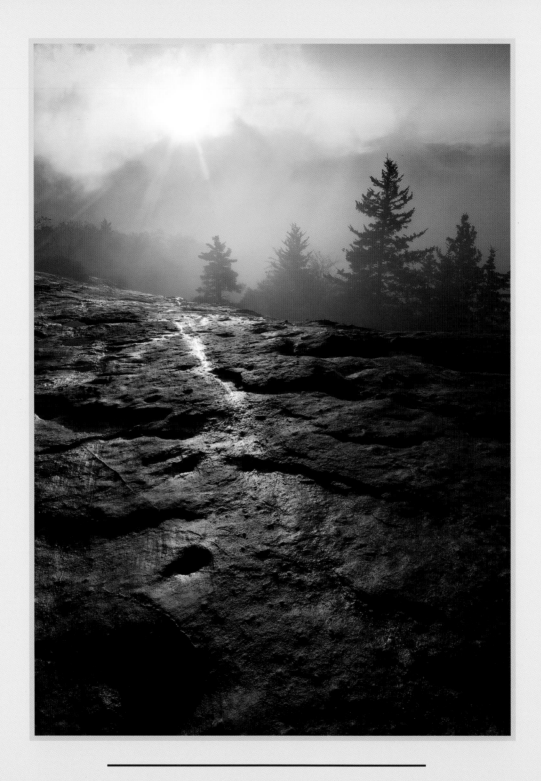

Breaking storm at sunrise, Beacon Heights, Blue Ridge Parkway

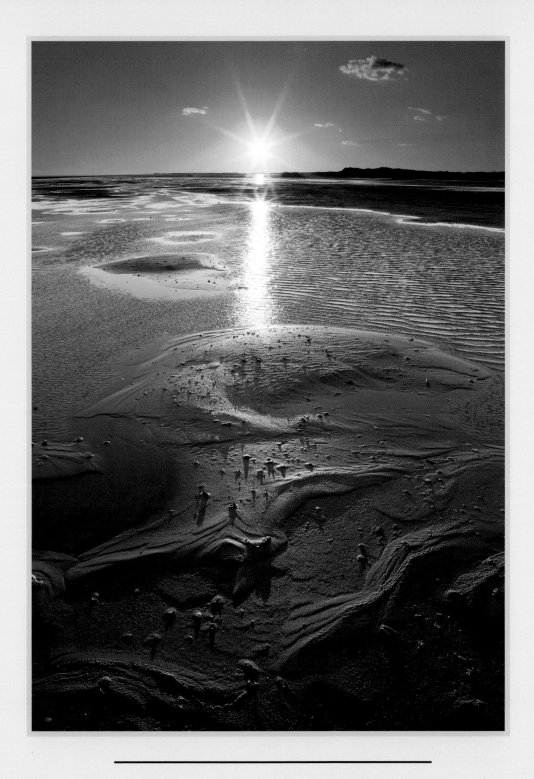

Sunset over the tidal flats at Southpoint, Cape Hatteras National Seashore

*Overleaf:* Winter cypress and tundra swans on Lake Mattamuskeet, Mattamuskeet National Wildlife

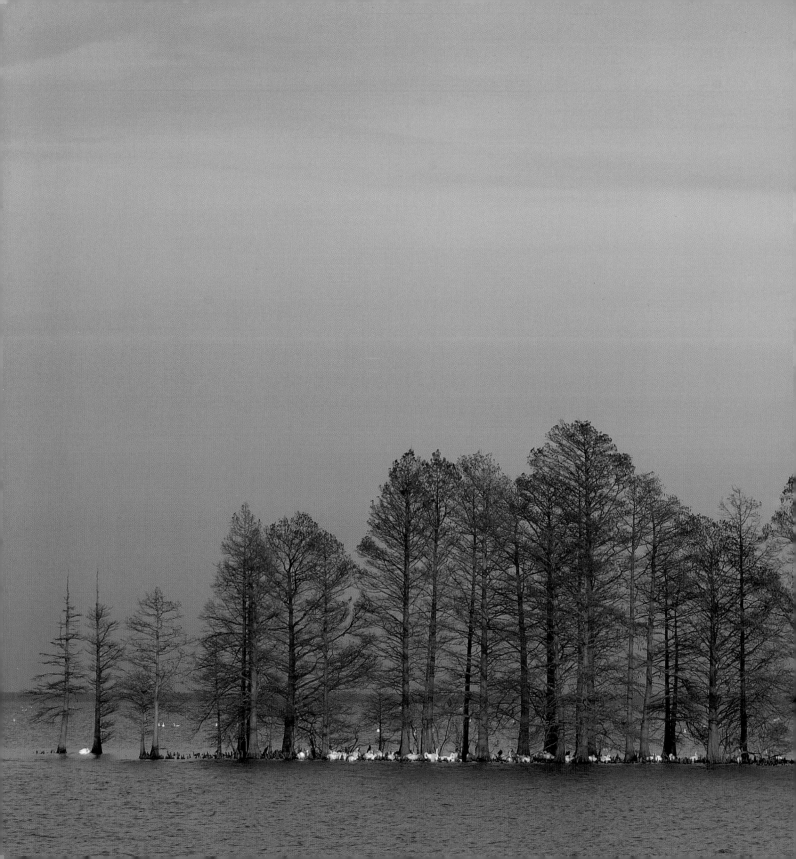

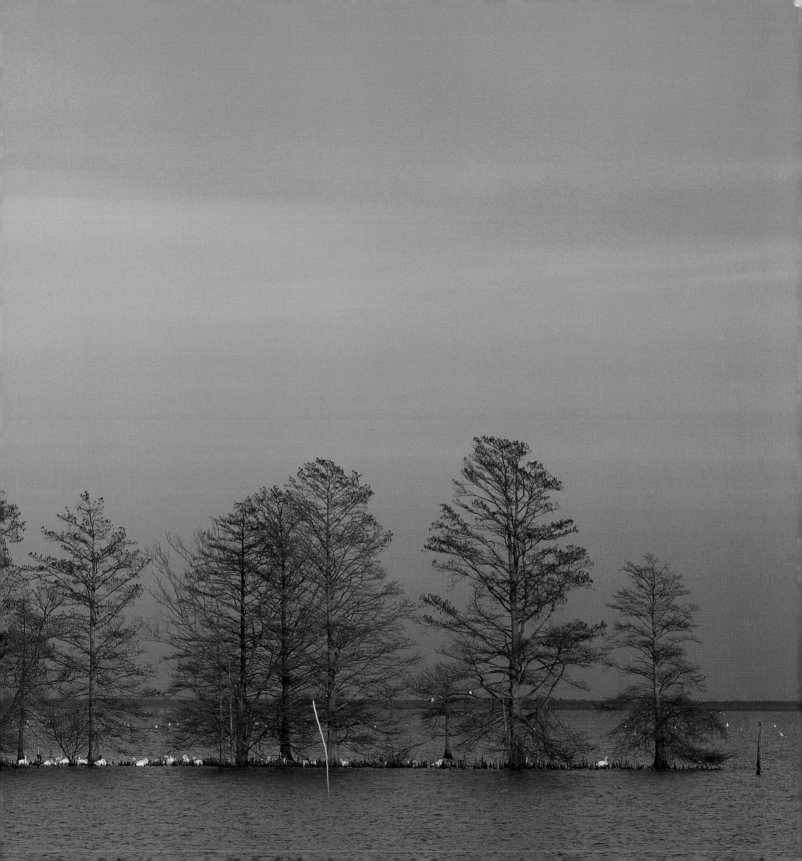

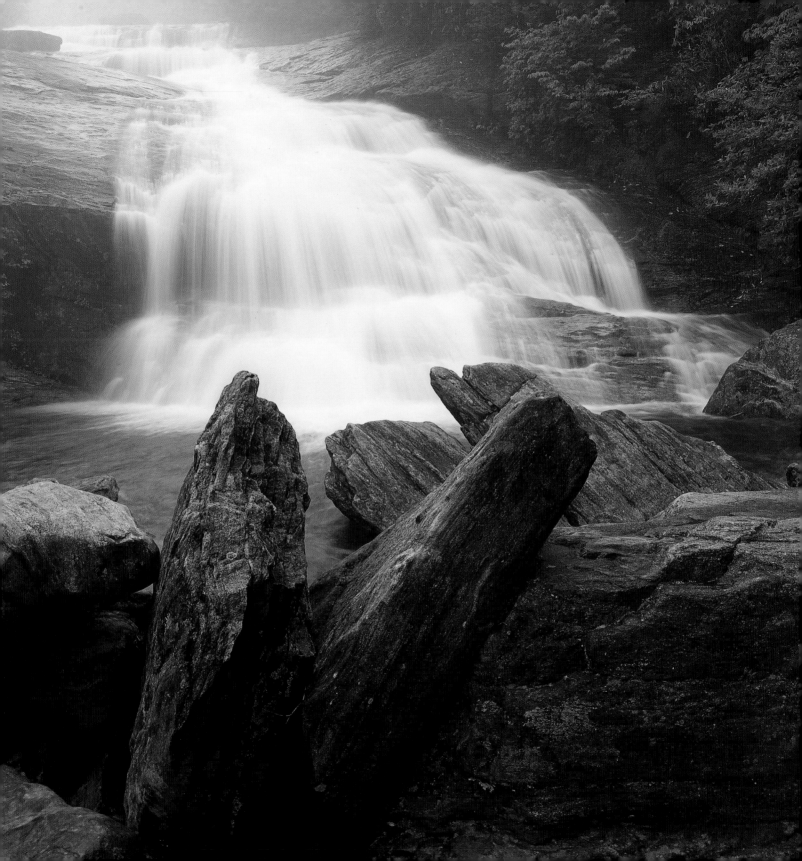

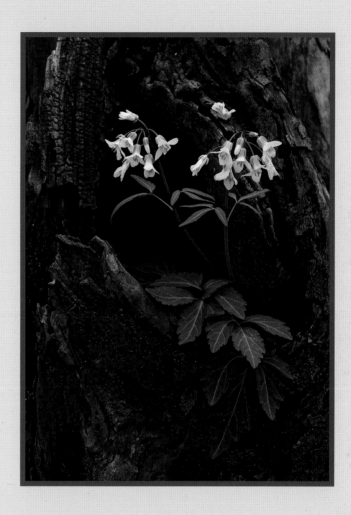

GRAVEYARD FIELDS is the headwaters of the Yellowstone Prong of the Pigeon River. Accessible by the Blue Ridge Parkway, it is a wonderful place for a hike in the high country. Second Falls, seen here, is the most accessible and beautiful of the three waterfalls on Yellowstone Prong.

*Above:* Toothwort growing from an old decaying tree, Great Smoky Mountains National Park

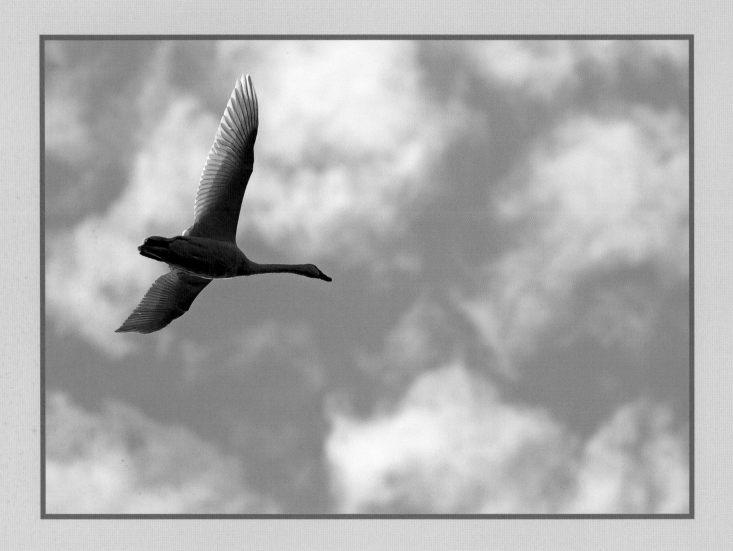

*Above:* Tundra swan, Pocosin Lakes National Wildlife Refuge

*Right:* Sunset and cattails reflected in Mattamuskeet Lake, Mattamuskeet National Wildlife Refuge

*Overleaf:* Ocracoke Lighthouse stands guard at sunrise

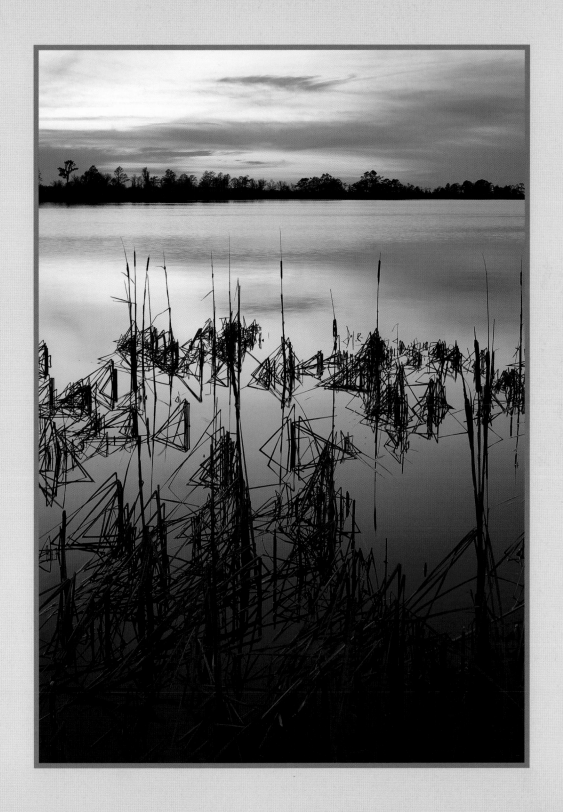

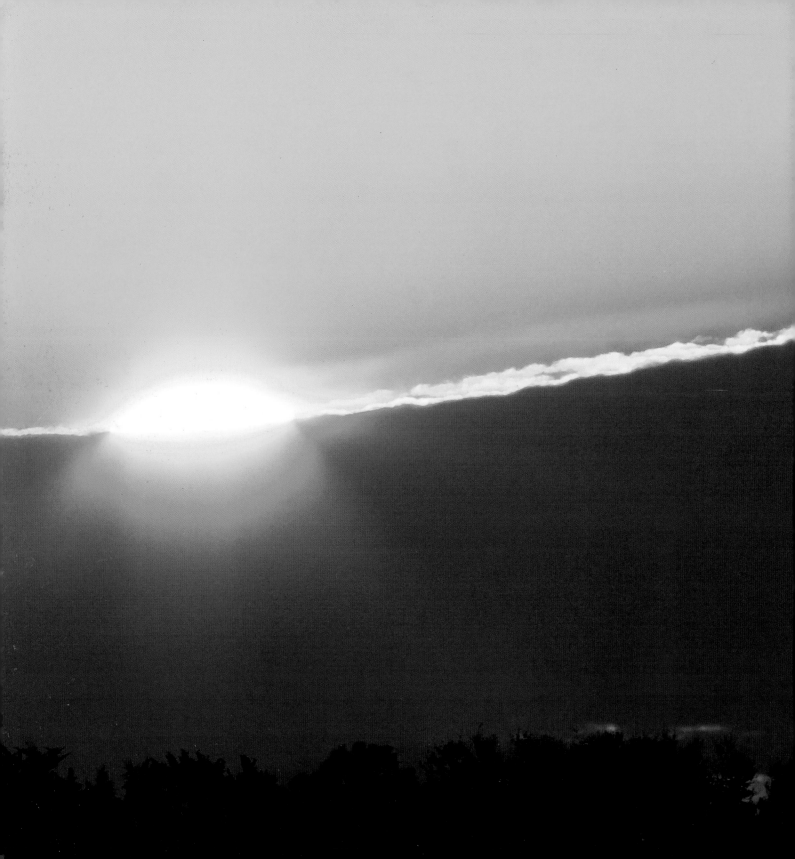

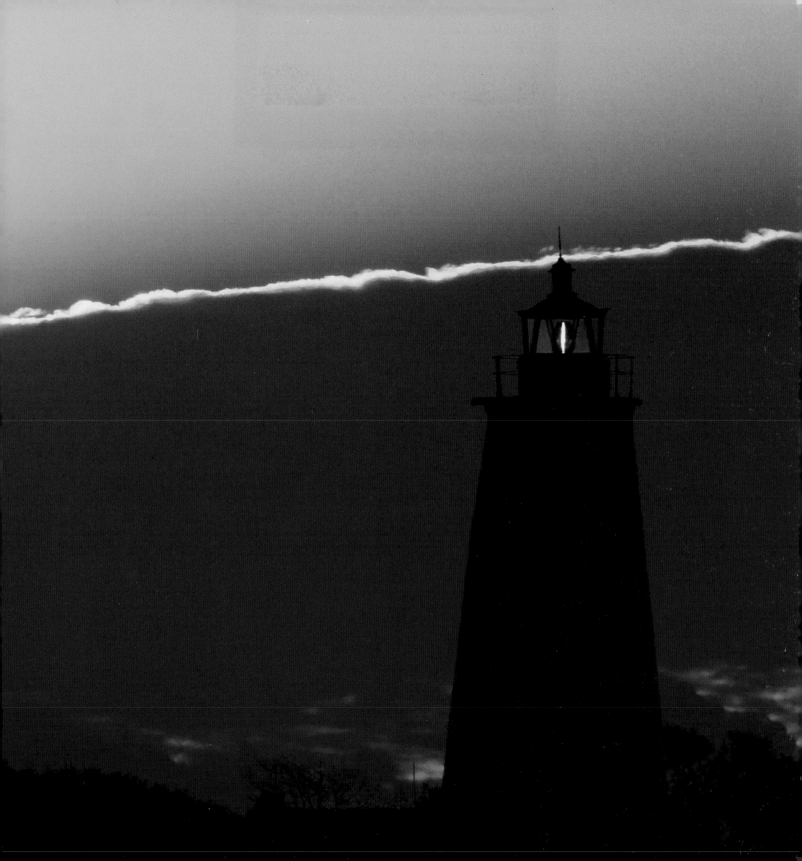

7/24/06

_____

*Above:* Sunset from Grassy Ridge, Roan Highlands

*Back cover:* Last light, Ocracoke Beach, Cape Hatteras National Seashore

**About the Photographer:** Jerry D. Greer has been photographing our scenic and wild places for over 15 years. His work has been published in regional and national publications, posters, calendars, fine art exhibits and books. Jerry, a native of southwest Virginia, now makes his home in Johnson City, Tennessee with his wife Angela. Jerry is the author/photographer of two photo essay books and a annual wall calendar. He has also co-authored two photo essay books and one annual engagement calendar. This will be Jerry's third book as the principal author/photographer.

More of Jerry's images may be viewed on his website, www.jerrygreerphotography.com.

Information on Jerry's other book and calendar projects can be found at www.mountaintrailpress.com.